Photoshop

Disclaimer

Table of Contents

Introduction

Photoshop was launched in February of 1990 and its launch totally changed the way digital images were handled. It caused a stir in the global creative community and made it really easy for everyone to edit images without the need to buy expensive equipment. The revolution started by Photoshop in 1990 is still alive today. Despite other software in the market like Paint.net, Photoshop still provides the best flexibility and user interface. That is why even after facing competition for more than 22 years, Adobe Photoshop is still the global standard for every company to edit and build images.

Over the years, Adobe has added extra features to Photoshop, making it more complex for beginners to learn Photoshop from start to finish. This book provides a path for beginners to follow with which they can not only start using Photoshop today but will also be able to build their basic foundation in Photoshop so that they don't face any difficulty in learning the complete Photoshop later.

In this book, you will learn the tools, panels and basics of Photoshop. By reading this book, you will find that there is more than one way of doing the same task. You are correct. Photoshop is a vast software and each task can be completed in a number of ways. For beginners, I recommend finding a method that they like and just stick to it. Don't confuse yourself by trying to implement every single available method. So let the learning begin.

Different Version of Photoshop

If you ask a Photoshop expert, or even if you just do a Google search, you will see that there are two names which keep coming up when you search for Photoshop. These are, Adobe Photoshop CS and Adobe Photoshop CC. Most beginners are confused between the two versions. That's why I want to clear the difference in CS and CC version of Photoshop before moving on in this book. CS in Adobe Photoshop stands for Creative Suite, while CC stands for Creative Cloud.

A Creative Suite is a standard desktop Photoshop Application like other apps that you have on your desktop. A major release is made by Adobe every two years or so, and the user needed to pay once in order to get that release. Each release used to be packed with updates and new features. However, Adobe has now moved from CS to CC.

A Photoshop Creative Cloud is also a desktop application that you download and install on your computer. However, it is a bit different from the CS version. Creative Cloud is continuously updated by Adobe as its developers work on bug fixes and releasing new features. All these updates are downloaded automatically to the user's computer by Adobe manager. In order to use the creative cloud, a user has to subscribe to a monthly subscription of the software, just like they subscribe to any monthly magazine. The CC version has more features than CS version (more than 15 new features were added in 2013 and still counting).

Both versions work the same and that's why it does not matter which Photoshop version you have right now. This book will assist you for both versions.

Getting Started with Photoshop

Before you start using Adobe Photoshop for editing images, you first need to make yourself comfortable with the Photoshop workspace. A workspace is an area on your screen where you work in Photoshop. Photoshop is infinitely customizable and modular in its layout. When you open Photoshop for the first time, you will see all the tools listed on the left side of the screen, while all the panels are on the right side of the screen. Besides the tools and panels, you will also see a standard menu at the top of your screen.

Photoshop Workspace

Below is an image to give you an overview of the workspace of the Adobe Photoshop including various panels and a tool bar.

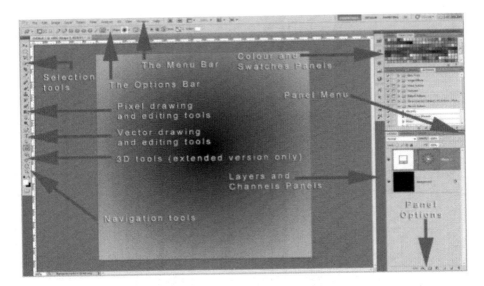

In the above image, you will see the following elements:

- The menu bar
- The options bar
- Left side tool bar including selection tools, navigation tools, pixel drawing and editing tools, 3D tools, and vector drawing and editing tools.
- Color and Swatches Panel
- Panel Menu
- Layer and channel panels followed by panel options

In both Photoshop CC and Photoshop CS, you will see these elements. The position of few elements may differ, like color swatches may appear at the bottom in Photoshop CC, unlike on the right side in Photoshop CS. But, it doesn't matter as in both of the versions, all the elements, with the exception of menu bar, are mobile. You can drag them around and place them anywhere to create your own working place. You should have all the above mentioned elements on your

Photoshop screen. If you are not able to see some of the elements, then you will have to get them on screen manually. Simply go to menu bar, click Windows and select a workspace. Now you can get all the elements on your screen. Now, let's discuss each element in Photoshop.

14

The Tool Bar

The tool bar, also known as the tool panel, is located on the left side of the work area by default. It contains many mouse based tools that a user selects while working in Photoshop for editing and navigating purposes. In the above workspace image, I have already named the various sections of tools that are present in this tool bar. These sections are created by Photoshop itself to loosely group the tools based on their functionality. You will see that these sections are separated by a small line. The first group of tools is selection tools, which are followed by pixel editing tools, vector editing tools and navigation tools. After all the sections, you will see a color picker at the bottom of the tool bar and an icon that allows you to enter the quick mask mode for editing and creating selections. The tool bar is summed up in one image below to help you understand better.

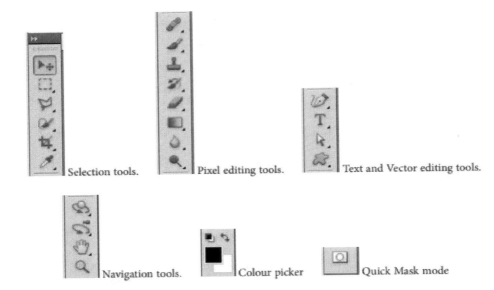

Selection tools. Pixel editing tools. Text and Vector editing tools.

Navigation tools. Colour picker Quick Mask mode

In the above image, you will notice that most of the tools have a small black arrow at the right bottom. Most of the beginners ignore this arrow icon. This icon actually means that there are more tools that can be accessed by the user by clicking and holding the tool. Once you do that, a list of extra tools will appear. After the list appears, you can release the mouse and the list will remain for you to make a selection. A comprehensive example of the extra tools list is shown in the image below.

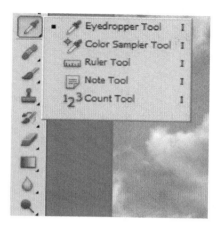

Now, let's investigate some of the common tools used by beginners in Photoshop. It is recommended that you follow this book to open these tools and try using them as you read about them for better understanding.

The Move Tool

This is the most widely used tool in Photoshop or in any other image editing software available. You can move objects around the photoshop campus using the move tool. Click any point on the canvas and drag.

The Marquee Tool

The next most widely used tool for beginners is the marquee tool. The user can select the canvas in a shape of this choice. A rectangular shape is default, but the user can change to an ellipsis shape if needed.

The Lasso Tool

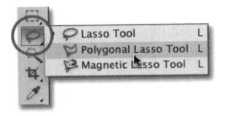

This is the tool which gets all beginners excited in Photoshop. Most users start selecting with Lasso Tool even in the case where a marquee tool can be used. The lasso tool lets you choose different parts of the canvas like a lasso, in a free-form manner. You can choose a polygonal lasso or a magnetic lasso tool. The magnetic lasso automatically detects edges for you.

The Magic Wand Tool

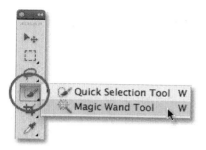

This tool makes selection and editing easy when an area of similar color is to be selected quickly. This tool can be used as an out of the box method to remove backgrounds from photos. Using this tool makes photoshop select the spot that's selected and anything around it.

The Crop Tool

This tool is used to crop or cut and picture in Photoshop to any size that you wish.

The Eyedropper Tool

The Eyedropper lets you pick any color in your foreground or background as your selected color.

The Healing Brush Tool

This is another famous tool for both beginners and intermediates of Photoshop. This lets you use part of the photograph to paint over another part. Photoshop will blend the surrounding areas of the picture as required.

Pencil and Paintbrush Tools

This is like being used as a pencil. It can be adjusted to various sizes and shapes.

The Eraser Tool

This is another tool that you must be familiar with because of the Paint application on your desktop or laptop. The eraser tool is almost identical to the paintbrush tool in Photoshop. The only difference is that it erases instead of painting a canvas.

The Paint Bucket & Gradient Tool

Again, the paint bucket is already known to you, but the gradient tool is a new term for you, right? I am going to explain both of them simultaneously so you will understand better. The paint bucket tool works in a similar manner to the paint application, and lets you fill it in with a certain foreground color. The gradient tool will blend the background with the foreground by creating a gradient. You can choose level and type of gradients required. These preset gradients are available in two or more colors which you can use.

The Pen Tool

Suppose that the magic wand tool was of no help in changing the image's background because the background and image were very similar in color. In such cases, using a pen tool acts as a life saver for

Photoshop users. Mastering the pen tool is the most challenging part for Photoshop beginners. But believe me, once you start using it, you will love it. As this tool is really important for Photoshop users, let's learn in detail about how to use it.

To start with the Pen tool, open an image with a basic shape in Photoshop. Now, select the pen tool and click to create the edges of your shape. After completing it, you will see a little O if you hover over the first point. You can then click on that first point to close the shape. Hold ALT/OPT and click on a point to turn it from a curve to a straight line, and vice versa. It sounds really simple, doesn't it? But once you start using it, you will understand how much patience is required to master this small yet important tool.

The Text Tool

You must be familiar with this tool from the paint application on your desktop. However, the text tool is a little bit advanced in Photoshop. The text tool in Photoshop allows you to write in two different ways. It is really important that you understand both of these. The first way is

how most people use text, by using what is called the Point text tool. You simply click on the Text Tool in the tools palette, click back on your image and start typing. The other way is to click on the Text Tool if it's not already clicked. Take the text tool and DRAG it out to make a rectangle. Now, you will be able to type in this rectangular box and all the text that you type will be constrained by this box. This is known as Paragraph text. The paragraph text can be aligned in the box to the left, right, center or justify format as per your needs. One of the advantages of having a CC over CS is that CC support offers more fonts than CS version of Photoshop.

The Shape Tool

This tool makes creating simple shapes easy. With this tool, you can create vector rectangles, rounded rectangles, circles, polygons, lines, and custom shapes. These shapes are very useful when designing or when creating shape masks for photos.

Source: Lifehacker, "Learn the Basics of Photoshop in Under 25 Minutes"

The Options Bar

The options bar is another important element of the workspace. I call it the sensitive bar as it is sensitive to the tool that you select for working in Photoshop. This bar provides access to the important configuration settings for a particular tool that is active in your workspace. For example, in the image below, you can see the options bar showing various options for the move tool.

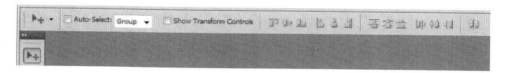

The Menu Bar

The menu bar consists of many menus and submenus which provide the user with various features of Photoshop that he can use in his work. We are going to discuss a little about all these menus to give you the basic idea of what is in each of the menus.

File Menu

This menu deals with an opening, saving a project along with exporting of it in different formats (discussed later in this book).

Edit Menu

It deals with copy, cut, and paste. In Photoshop, it's also where you transform layers and set your color spaces.

Image Menu

The image brings you canvas and image adjustments, it includes destructive effects. Options in this menu are designed to affect the image as a whole, although many adjustments are applied to only a single layer.

Layer Menu

Layers are discussed later in this book, so let's not stress about it here. For now, just understand that this menu also lets you create adjustment layers and smart objects.

Select Menu

The name itself will give you the basic idea of this menu. While the marquee and lasso tools will be your main means of selecting things, along with the pen tool once you will learn how to use it. But still, the select menu can help you refine that selection or create entirely new selections based on some criteria.

Window Menu

The window lets you hide and show certain windows and palettes. You can also arrange your Photoshop windows and palettes however you want and save them as a window preset.

There are many other menus like 3D, View which is not discussed as these are not much use for beginners in Photoshop. For now, let us just stick to the menus discussed in this book and move on to the next chapter.

Basic Operations in Photoshop

Before you start thinking about what could be the basic operations in Photoshop, let me tell you they are far more basic than you think. These are:

Opening a file

Saving a file

Starting a new document

Exporting a project

These may sound too basic and you may feel like skipping this chapter. **Don't.** At the end of this chapter you will understand there was so much that you didn't know about these operations before reading this chapter. So, let's start.

Opening a File

It is easy to open a file in Photoshop. The process is simple and the same as every other software that you use on your computer. Press Ctrl+O or go to file menu then click open and select the file that you want to open.

However, Photoshop comes with another option which is **Open As**. So, what is Open As? With this option, you will have the flexibility to open a file in a certain format in Photoshop in a totally different format. You

will get a better idea with the help of image that you will see at the end of this paragraph. One useful application of this command is that you can open most of the single layer file formats in Camera Raw Document format. After opening your file in this format in Adobe Photoshop, you can easily make simple adjustments to your image without having to deal with any complex techniques in Photoshop.

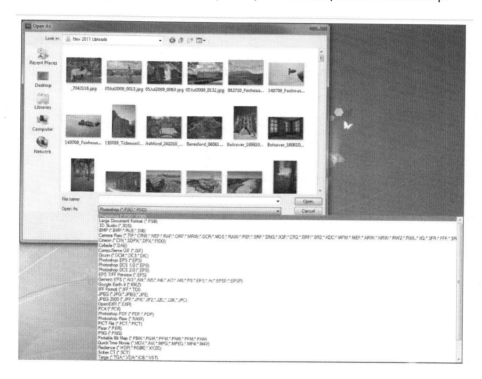

Another important term in this basic operation is **Open as Smart Object.** Opening a file as a smart object allows you to make non-destructive editing on your opened file. This is useful when you are planning to do extreme transformations on your image. When you

open a file as a smart object, you see it in the layers panel on the right side of the workspace with a small icon at the bottom right side of the file. From there you can turn the smart object ON and OFF for the file. Thus, it is clear that you can change a smart object file to an ordinary Photoshop file whenever you like.

Saving a File

The next basic operation of Photoshop is saving a file. You must be familiar with both the **Save** and **Save As** command from various applications on your computer like MS Office, etc. However, I will discuss **Save As** in a little detail with you in this section. **Save As** works just like any other desktop application but the file formats provided in Photoshop are completely different. Below is an image to show you the vast list of file formats that Photoshop allows you to save your work in.

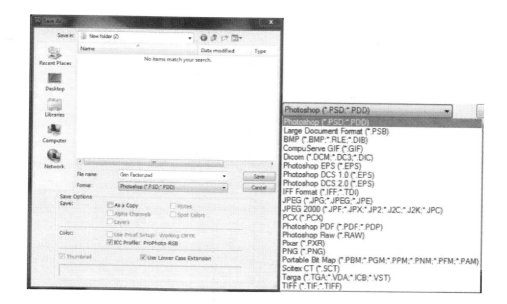

A beginner needs to understand various file formats that are used
frequently for saving the work from Photoshop. These are as
important as the tools that we discussed in the previous chapter.
Learning about the most frequently used formats will build your basic
foundation in Photoshop very quickly.

Frequent File Formats Used to Save the Work in:

PSD: It is the Photoshop's native or default file format. Whenever you
save a file, the default format that Photoshop will select is PSD. It
doesn't matter if the file that you were working on is a .jpg, PNG or of
any other format. This format provides you the maximum flexibility in
saving your work as it will retain all the layers, adjustments and effects

in the manner that you applied. However, the file size for PSD format is large.

TIFF: This format is also known as TIF. It is somewhat similar to the PSD format. The main difference is that when you save your work in TIFF format, you will be able to open it in maximum image editing software as TIF format is compatible with most of the image editing software, unlike PSD. Moreover, TIFF format allows you to save your work by taking less amount of disk space than PSD due to its high compression methods.

JPG: Also known as JPEG. This is by far the most widely used image file format followed by GIF and PNG. This file format is mostly used for the images that you want to display on a screen or on the web. The file size of JPG format is smaller than PSD and TIFF. This is because most of the work is lost in the compression process thus only reflecting the final result and not saving any layers or adjustments separately like PSD and TIFF format.

PDF: You may be surprised but PDF format is really popular in Photoshop. It is very useful for displaying files across multiple applications and platforms. It provides the user with the benefit of compression and common color modes, while retaining font, vector and Photoshop editing.

Another file format which is popular in Photoshop is PNG and GIF. PNG is mostly used for making transparent images like a logo, etc., while GIF is used for making small animation images.

Creating a New Document

Creating a new document has the same command like any other computer software. Go to File and select New, or simply click Ctrl+N from your keyboard. Now, you will get a new dialogue box to set up the parameters for your new Photoshop file to start working. Most of the beginners accept the default settings or get confused in what parameters to select. Another common mistake is that each project you work on will have different sizes and resolutions for the intended purpose. Thus, using the default settings may not work sometimes. Setting up a page properly in Photoshop is really important and thus I am providing you with details of some of the most widely used settings in Photoshop for creating a new file or document.

Preset: Here, a user can select a preset for his new file. Each preset has different page sizes related to it, which can be seen in the drop-down menu below the preset. The preset size that you select will automatically set the resolution for print.

Color Mode: In color mode, RGB and CMYK are present as options. As a beginner, you should keep in mind that RGB is used for photography and web design, while CMYK is used for commercial purposes.

Bit Depth: Bit depth is another important option which is often ignored by beginners. The options in bit depth are 8 bit and 16 bit. Out of these two, the 8 bit is generally used when the user wants to do simple work unless he wants to perform some advanced image editing, which includes a lot of gradients in the design. For such cases, the 16-bit mode is used. When working with the 16-bit mode, once the user

completes the work, he changes the work to an 8-bit mode as the web graphics or images are always presented in 8-bit mode.

Background Content: This option gives you the flexibility of deciding the default background color for your document.

Pixel Aspect Ratio: This setting is available in the dialogue box under advanced section. In almost all the cases, the square pixels are used. The rectangular pixels are only used when you want to display your content on a wide screen. Besides this option, the **color profile** is another important option in the advance section. I recommend you do not change anything in this section which is keeping sRGB by default. However, if you want to do some advance photographic work, then you may select Adobe RGB or Pro Photo RGB.

Most of the time when I tell beginners about color profile, I get asked the question, "What is the difference between sRGB and Adobe RGB?" For now, just keep in mind that Adobe RGB has a much wider range of colors than sRGB. Adobe RGB has 35% more color range than sRGB.

After selecting the appropriate parameters in the dialogue box, you are all set to start working in the Photoshop file. Simply click OK to get the canvas on your Photoshop screen and start working. If you are a beginner, then start with the tools that were explained earlier in the book. Use them often to get used to them.

Exporting a Project

Another important feature of Adobe Photoshop is exporting a file. However, most of the people working in Photoshop are confused in Save As and Export. This is because the work of both of these features is almost the same. With Save As, you can save the file in a different format on your computer using the Export button. However, when you save a file by using the Export function, that means that you are saving the file for some other program, whereas if you will save the file using the Save As option, it will tell Photoshop that you are saving the file for this program itself (that is the Photoshop). When you use Save As for the file, it will save the file and will let you work over that file itself in the Photoshop screen. However, if you use the Export function, then Photoshop will create a new file for the project which is not active in the Photoshop screen. Thus that file will remain unedited.

These are the basic operations in Photoshop.

Layers in Photoshop

If you thought that mastering the pen tool is the only challenge in Photoshop, then think again. Layers in Photoshop are always confusing for beginners. Beginners are known to have problems with the concept of layers and how they interact with one another in Photoshop. Layers can be grouped, duplicated, flattened, clipped, linked, renamed, reordered, blended together and hidden using the layer masks. These terms may sound overwhelming, so that's why I prefer to start from scratch on layers.

What Are Layers?

Layers are simply objects, text, images, or stacks of colors. Layers are very powerful and allow a user to edit and control the individual component without affecting any other element on the canvas in the Photoshop. The arrangement of layers plays an important role in creating images or scenes in Photoshop. Let's discuss the layers further with the help of an example.

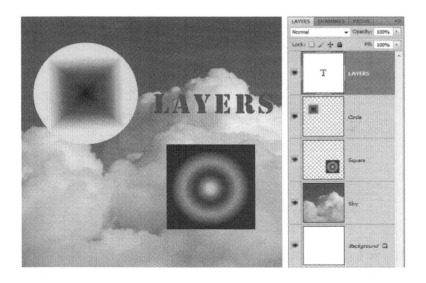

In the above image, it is clear that all the layers that are present in a Photoshop project can be seen in the layer panel located at the bottom right side of the screen. In the image above, you can see that there is a total of 5 layers, namely the background layer, the layer with the image of the sky, the layer with the image of a square, the layer with the image of a circle and at last, the layer with text. The layers are placed based on their arrangement in the layer panel from bottom to top. As you can see the bottom layer is the background layer, which is just below the sky layer. That is why the sky layer is covering the white background layer in the image above. The square layer is above the sky layer and has a transparent background. That is why, the square is placed over the sky in the canvas and due to the transparent background, no extra white spaces are added around the corner. The circle layer is placed above the square layer in the canvas in the same manner. The top most layer is the text layer, which is a special kind of

37

layer. The text layer always has a white background in the layer panel. However, on canvas, the text layer always has a transparent background.

Moving Layers in Photoshop

Did you see how much your project is affected by the arrangements of the layer in the layer panel in your Photoshop? However, let's say that you want to place a square layer above the circle layer. You can do that by simply moving the layers. Moving layers in the layer panel is really easy. All you have to do is select the layers to move and then drag them up or down to the place where you want them to be in the layer panel.

Selecting the layers

When you want to select a single layer, you can do so by just clicking the layer in the layer menu. Once the layer is highlighted, then you can move it by dragging it. However, if you want to move a lot of adjacent layers, then, you can select them by clicking the first adjacent layer, then holding the shift key and clicking the last adjacent layer. After you do so, all the layers in between the first and last layer that you selected will be highlighted. Now you can move them by dragging. If you want to select multiple non-adjacent layers, then you can do so by clicking one layer, then holding the Ctrl key and clicking all the other images that you want to select. Later you can move them by dragging as usual.

Aligning the layers

When you move the layers by selecting them, they will still maintain their relative position. If you want to change the position of layers with respect to one another, then you can use the align tool. Aligning the layers is done with the help of the options bar of the layers. Let's have a look at the option bar first.

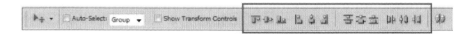

The icons in the red box in the image above are the options to align the layers. After selecting the layers just click the aligning option that you want to use to align the layers to one another. Below is an image explaining the meaning of various aligning options available for layers.

▯ Align top edges

▯ Align vertical centers

▯ Align bottom edges

▯ Align left edges

▯ Align horizontal centers

▯ Align right edges

▯ Distribute top edges

▯ Distribute vertical centers

▯ Distribute bottom edges

▯ Distribute left edges

▯ Distribute horizontal centers

▯ Distribute right edges

Adjustments in Layers

Opacity

The manner in which one layer may interact with other layers in Photoshop can be edited easily in a number of ways to suit the needs of the user. One such adjustment between layers is Opacity. Let's first have a look at the options that you have in the layer panel for the select layer.

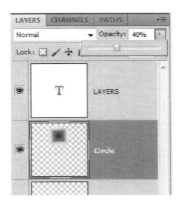

You will see two options. One of them is named opacity and is provided with a slider. By default, the opacity of every layer in Photoshop is 100%, but you can edit it easily by changing the value on the slider in the opacity option in the layer panel. Moving towards the left of the slider will reduce the opacity of the image (or layer containing that image) and moving towards the right will increase the opacity. Alternatively, you can just enter the opacity value manually. In the above image, we have changed the opacity of the circle layer to 40. Below is what the circle looks like after changing the opacity.

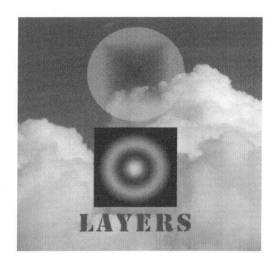

Blending the Layers

In the layer panel, just before the Opacity option, there is a drop-down, which has a value as 'Normal'. This drop-down is to assign a blend mode to the layers. Blend mode allows one layer to affect layers underlying it in a number of ways. You can select the blend mode for your layers using the drop-down and then by selecting an appropriate option.

Naming the layers

Layers by default are named as 'layer1', 'layer2', etc., by Photoshop. Thus, it is really easy for a user to lose track of his work as he will not be able to remember what layer has what components in it. Naming the layers makes it really easy for a user to keep track of his work. In the previous screenshots, you must have seen that all the layers were named based on the component that they contained (sky, circle, etc.).

To rename a layer, simply double-click the layer name in the layer panel and then type a new name.

Shape & Text Layers

Shape layers are created in the Photoshop automatically when you use the shape tool to draw shapes in your project. Similarly, the text layers are created automatically when you use the text tool in your project. When you create a shape using the shape tool, the following option comes up on the option bar.

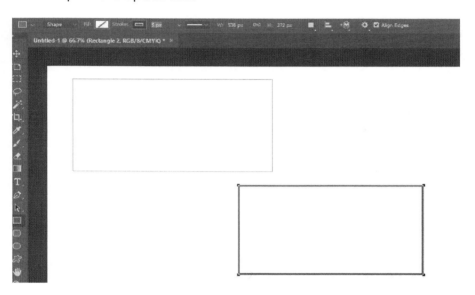

I have created two rectangles to help you understand the necessary options from the option menu. In the option menu, you will see **Fill** and **Stroke, W** and **H.** You can draw a rectangle by clicking and dragging on the canvas, and can adjust its width and height with the

help of **W** and **H** respectively. The **Fill** command will help you fill the shape that you created with a color and the **Stroke** command will help you make a shape with varying width of the outline. For example, in the image above, I have created one rectangle with 1px of stroke (the upper one) and one rectangle with 5px of strokes (the bottom one). You can simply enter the stroke value that you want. Next to the stroke value is a line drop-down available. From this drop-down, you can select different kinds of lines for your shape, like a solid line, dashed line, dotted line, etc.

Working with Images in Photoshop

Working on images to edit and modify them is the main reason why most people start using Photoshop. What you learned in this book until now must have familiarized you with Photoshop and various tools. However, I kept certain tools isolated until now so that I can explain them in this chapter. After reading and following this chapter, you will be able to edit images easily. But, first things first, let's start by discussing the tools.

Navigation & Zooming

If you would have paid enough attention in the previous chapters of the book, then you must have noticed that nowhere did I talk about any of the navigation menus. If you noticed this then you are a quick learner, if not then don't worry, it happens with many beginners.

The Zoom Tool

The zoom tool allows you to zoom in and zoom out of your canvas in Photoshop. With this tool, there are two ways to zoom in. One is by selecting the zoom tool and clicking on the desired portion of the image to zoom in predefined increments. The second is to select the zoom tool and then drag on the image to define the particular area that you want to zoom in on. Now, let's take a look at the option panel for the zoom tool. If you don't remember the option panel, then I advise you to go back to Chapter 3 and review it.

The magnifying glass with + on it indicates the zoom in option while the magnifying glass with a – icon on it indicates the zoom out option. You can zoom out of the image by clicking on this icon.

If you look at the above image closely, then you will see that an option named **scrubby zoom.** This option is checked by default in Photoshop. If it isn't, then I recommend you check it manually. Scrubby zoom allows you to quickly zoom in and zoom out of your image by clicking and dragging. If you want to zoom in, then click on the image and drag to the right side of the screen. Similarly, if you want to zoom out, you can do so by clicking and dragging towards the left of the screen.

Actual Pixels in the option bar will show you the image at 100% magnification. **Fit Screen,** as the name indicates will fit the current image to your workspace screen respecting the panels and the toolbars. **Fill Screen** will zoom in and fill all your screens with the image irrespective of the panels and toolbars on your screen. **Print Size** will show you the actual printing size of the project based on the document settings that you selected while creating a new document.

The Hand Tool (Pan Tool)

After you zoom into your image, you can use the hand tool for moving the image around. Just select the tool from the navigation section and then go back to your image. Click and drag to move around in the image. If you are working on your project and don't want to change the tool, then you can just press the spacebar button on your keyboard

to activate the hand tool. Your original tool will be selected automatically by Photoshop as soon as you release the spacebar button on your keyboard.

The Navigator

When you zoom into your image and move around, it is really easy to lose yourself. In this case, you can either zoom out and check your position, or simply access the navigator in Photoshop. When you turn the navigator ON, a red box will appear in the navigator dialogue over your image which will tell you about your current position in the image. Navigation can also be undertaken by dragging this red square to a new position on the image.

Navigation and Zooming plays an important role when you are editing images. That's why I kept this part for this chapter of the book. Now, let's move on and do some image editing in Photoshop.

Basic Adjustments for Images in Photoshop

In this section, I am going to tell you how to edit the whole image to adjust its size, and how to apply adjustments to the image, for example, color, brightness, etc. There are two ways to apply adjustments in Photoshop. The first is to go to the Image menu in the Menu bar and then going to Adjustments. In the Adjustment submenu, you will see a total of 22 adjustments or edits available. Any adjustment that you make with this method is permanent and destructive. That means, once you save the file, you won't be able to undo the changes the next time you open the file. The second method

to apply adjustments or edits is by using the layers. The editing done with this method is non-destructive. To make adjustments with this method, go to Layer menu in the Menu bar and then go to New Adjustment Layer. This time, you will notice that there are a total of 15 adjustments available instead of 22. However, all the essential adjustments are present in these 15.

After adding an adjustment layer, it will be shown in the layer panel above your image. The dialogue box for the adjustment that you selected will also appear next to the layer panel. Though there are many adjustments in the adjustment submenu, only a few are the most widely used. These are:

Brightness/Contrast

Black and White

Levels

Hue/Saturation

Let's learn these adjustments one by one, starting with the Brightness.

Brightness/Contrast

With this adjustment, you can control the brightness and contrast of your image. Simply select 'Brightness/Contrast' from the New Adjustment Layer. After selecting this option, you will see a new dialogue box near the layer panel with two sliders to adjust these two features (adjustments) of your image. Taking the slider to the left will decrease the value of the two adjustments while taking the slider to

48

the right will increase the value. Values can range from -150 to +150 for Brightness, -50 to +100 for Contrast.

Black and White

This adjustment is used to turn a color image to a black and white image. This adjustment is the most powerful and effective way to create monochromatic images in Photoshop. To apply this adjustment, go to the Layers menu, then to New Adjustment Layer and select Black and White. After adding this adjustment, a new dialogue box will appear near the layer panels for you to create stunning monochromatic images. Now you can apply a new filter from the drop-down menu and can change the value of various colors with the help of sliders present in the dialogue box.

Levels

Levels are the most important and extremely powerful tool for adjusting the exposure problems and can also be used to correct the colors in the image. To apply this adjustment, simply go to Layer Menu, then go to New Adjustment Layer and select Levels. Below is the nomenclature of the dialogue box for this adjustment.

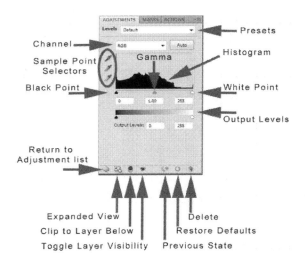

Channel —
Sample Point Selectors
Black Point

Gamma

Presets
Histogram
White Point
Output Levels

Return to Adjustment list

Expanded View | Delete
Clip to Layer Below | Restore Defaults
Toggle Layer Visibility | Previous State

When you apply this adjustment, you will see a histogram. This histogram represents all the tonal values present in the image. The black point on the slider just below this histogram is set to 0 which stands for pure black, while the white arrow is on 255, which stands for pure white. Apart from these two arrows, there is the third arrow in the middle of the gamma slider. If you move this arrow to the left, then the image will be lighter in the mid tone, whereas if you move this slider to the right side, the image will be dark on the mid tone. Thus, the middle arrow on the gamma slider works differently from the other two sliders.

Sometimes, the black and white arrow does not coincide with the gamma histogram. This is shown in the image below.

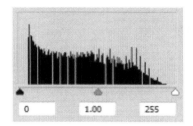

This means that there are no true blacks or whites in the image, which may lead to a lack of contrast in the image. To correct this, we can move the arrows to meet with the histogram.

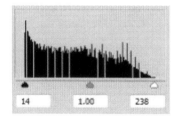

After correcting, the new values are 14 and 238. This means that the values less than 14 in the image will be shown as pure black and values greater than 238 will be shown as pure white. This is also known as mapping the values.

Hue/Saturation

This adjustment allows the user to manipulate the colors in the image both independently and globally. To apply this adjustment, go to Layers Menu, then go to New Adjustment Layer and then select

Hue/Saturation. After applying this adjustment, a new dialogue box will appear next to the layer panel with three main sliders. These sliders are Hue, Saturation, and Lightness. The Hue slider affects the color value of the image. Changing the color from the spectrum line will affect the coloring of the image. This adjustment is very useful when you use it for a specific color in the image. The Saturation slider represents the color intensity in the image. Moving the slider to the left will decrease the intensity of the colors and moving the slider to the right will increase the intensity of the colors in the image. Moving the slider to the extreme left will result in changing the image into grayscale. The Lightness slider is clear from the name and will change the lightness of the image. However, using this slider is an advanced technique and not recommended for beginners. This is because using this slider improperly can result in great loss of contrast in the image. Now, towards the bottom of the dialogue box for this adjustment, you will see an option called Colorize. If you will turn this option ON, then the whole image in your Photoshop screen will be tinted with a particular color. The Hue slider can still be used to change the tinted color and the Saturation slider can be used to change the intensity of the tinted color.

With this, we have completed the basic adjustments of the images that you can do with the help of Photoshop. Now, let's study a few more basic image editing options that are available in Photoshop.

Changing Size in Photoshop

When you are working in Photoshop, you can easily change the size of the image and the canvas that you are working on. To change the

image size in Photoshop, simply go to Image menu in the Menu bar, and select Image Size. After this, a new dialogue box will appear on your Photoshop screen where you can add the new values for the width and height of your image. Similarly, to change the canvas size, go to Image menu in the Menu bar, and select Canvas Size. After this, enter the new values for the canvas size.

The difference in Image size and canvas size is that, with image size, you will be able to change the size of the image that is there on your Photoshop screen, whereas, if you select the canvas size, it will add a blank area around the image (mostly white) if you increase the size, and will crop the image automatically if you decrease the canvas size.

Auto Tone, Auto Color & Auto Contrast

Photoshop has three automatic correction tools namely Auto Tone, Auto Contrast and Auto Color. With these tools, the user can improve the overall appearance of the image with a single click on the image. Let's discuss these three commands one by one, starting with the Auto Tone.

Auto Tone

This command automatically applies the Levels adjustment on the image with most accurate values which Photoshop generates based on its built-in intelligence. If you are looking to adjust the highlights, shadows or mid tones of an image, then Auto Tone is the best option for you to save you time.

Auto Color

This tool is mainly used to balance the color of the image. With Auto Color, you can adjust both the colors and contrast of the image based on the shadows and highlights. Using this command is helpful when you are trying to correct the saturation level in your image.

Auto Contrast

This command automates the Brightness/Contrast adjustment on your image. This tool makes changes to the image based on the overall color and contrast of the image rather than making adjustments to each color individually. This tool is useful in changing the highlights in the image to lighter and shadows to darker without changing the color values of the image.

Blurring the Image in Photoshop

In your Photoshop, you can easily create various types of blur effects on your image by activating the blur gallery filter and then using the on-image controls. In this section, I am going to tell you the basic method of blurring the images, which can be applied to all different kind of blur that are available in Photoshop.

To access the blur gallery, simply go to the Filter menu on your Main menu, and then go to Blur Gallery. You will see the following blue options there:

Field Blur

Iris Blur

Tilt Shift Blur

Path Blur

The method of blurring the image for all four types is the same and is discussed below:

First open the image and create a duplicate of it by pressing Ctrl+J from your keyboard. This way, the original image will remain safe, and we can work on the duplicate copy for applying the blur.

Next, go to the Filter Menu and then go to Blur Gallery. Now, select any of the blurs that you want to work with.

As soon as you select a blur (Field blur for example), you will notice that an initial blur is applied to the whole image by Photoshop and the field blur options will appear on the right side of the screen. The initial blur applied to the image is applied uniformly all over the image by Photoshop and has a small circular icon over it. The circular icon is known as **Pin**. This icon is used to pin on the image. By default, Photoshop adds one pin on the image but you can add multiple pins on your Photoshop.

These pins actually control the amount of blur that is applied to the image at the area where the pin is placed. The pin controls the blur amount with the help of the outer ring present with the pin. If you move in a clockwise direction in the outer ring, it will increase the blur

on the image. Similarly, if you move in an anti-clockwise direction, the amount of blur on the image will decrease.

The blur slider provided in the blur options on the right side of the screen works just like the outer ring of the pin. You can increase or decrease the amount of blur by moving the slider to the right or left respectively.

The initial pin and other pins that you add on your image for blur can be moved by clicking at the center of the pin and then dragging them.

You can add more pins on your image by just taking your mouse cursor to the place where you want to place the pin and then making a simple click over there.

Blur may sound simple and easy but it is a very complex process to master properly. Let's now have a look at some of the shortcuts that you can use while creating images or designs in Photoshop.

Shortcuts in Photoshop

Using shortcuts not only saves a lot of time but also helps in maintaining your focus over long projects. Below are a few of the most widely used shortcuts in Photoshop:

Photoshop Result	Shortcut
Rectangular Marquee tool Elliptical Marquee tool	M
Lasso tool Polygonal Lasso tool Magnetic Lasso tool	L
Magic Wand tool Quick Selection tool	W
Crop tool Slice tool Slice Select tool	C K
Eyedropper tool	I
Spot Healing Brush tool Healing Brush tool Patch tool Red Eye tool	J

Conclusion

Photoshop is a vast software and discussing every single feature is beyond the scope of this book. I have provided you with a brief overview of Photoshop which will help you start using Photoshop today and also build your foundation for learning advanced Photoshop. But, this book is of no use if you are just going to read it and not practice the tools and adjustments that I discussed with you. Open your Photoshop and start practicing today! Happy learning!

69416356R00035

Made in the USA
Lexington, KY
31 October 2017